VILLAINS

Art Studio

PROJECT BOOK

THUNDER BAY

P · R · E · S · S

San Diego, California

Thunder Bay Press
An imprint of the Baker & Taylor Publishing Group
10350 Barnes Canyon Road, San Diego, CA 92121
www.thunderbaybooks.com

All notations of errors or omissions should be addressed to Thunder Bay Press, Editorial Department, at the above address. All other correspondence (author inquiries, permissions) concerning the content of this book should be addressed to Walter Foster Publishing, Inc., 3 Wrigley, Suite A, Irvine, CA 92618.

ISBN-13: 978-1-62686-010-0
ISBN-10: 1-62686-010-6

Printed in Guangdong, China.

1 2 3 4 5 17 16 15 14 13

Art Studio

PROJECT BOOK

TABLE OF CONTENTS

Tools and Materials

SKETCHING PENCIL

The sketching pencil in this kit has a lead hardness of HB. This pencil won't smear easily like soft pencils or scratch the surface of watercolor paper easily like hard pencils.

COLORED PENCILS

This kit contains seven colored pencils. Be sure to store them in the kit or a container. The lead in a colored pencil is brittle and likely to break inside the shaft if the pencil is dropped. This may not be immediately apparent, but will eventually render the pencil useless.

FINE-TIPPED BLACK MARKER

Use the **fine-tipped** black marker to ink your drawings. You can also experiment with ink, brush, dip, and ballpoint pens for different effects. Whenever possible, work with black waterproof ink for more permanent results.

SHARPENER

You can achieve various effects depending on how sharp or dull your pencil is, but generally you'll want to keep your pencils sharp. A sharp point will provide a smooth layer of color.

KNEADED ERASER

The success of erasing colored pencil marks depends on two main factors: the color of the pencil line and the amount of pressure that was applied. Darker colors tend to stain the paper, making them difficult to remove, and heavy lines are difficult to erase, especially if the paper's surface has been dented.

WATERCOLOR PAINTS

This kit contains three watercolor paints in tubes. Watercolor paints are commonly available in three forms—tubes, pans, and cakes. Most artists prefer tubes because the paint is already moist and mixes easily with water.

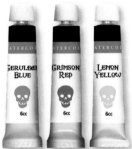

PAINTBRUSHES

Many paintbrush styles are available, but two are most commonly used with watercolor—flat brush and round brush. A flat brush has bristles of equal length that produce even strokes. A round brush has bristles that taper to a point, which allows it to hold a good amount of water. You can also vary your pressure on the brush to create a variety of stroke widths.

PALETTE

The plastic palette in this kit features several wells for pooling and mixing your watercolors. It's easily cleaned with soap and water.

Colored Pencil Basics

HOLDING THE PENCIL

The way you grip the pencil directly impacts the strokes you create. Some grips will allow you to press more firmly on the pencil, resulting in dark, dense strokes. Others hinder the amount of pressure you can apply, rendering lighter strokes. Still others give you greater control over the pencil for creating fine details. Experiment with each of the grips below.

 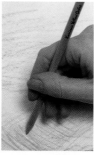 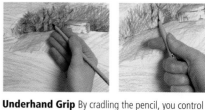

Underhand Grip By cradling the pencil, you control it by applying pressure only with the thumb and index finger. This grip can produce a lighter line. Your whole hand should move (not just your wrist and fingers).

Conventional Grip For the most control, grasp the pencil about 1¹/₂" from the tip. Hold it the same way you write, with the pencil resting firmly against your middle finger. This grip is perfect for smooth applications of color, as well as for making hatch strokes and small, circular strokes.

Overhand Grip Guide the pencil by laying your index finger along the shaft. This is the best grip for strong applications of color made with heavy pressure.

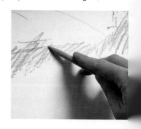

PRESSURE

Colored pencil is not like paint; you can't just add more color to the tip when you want it to be darker. Because of this, your main tool is the amount of pressure you use to apply the color. It is always best to start light so that you maintain the tooth of the paper for as long as you can.

Light Pressure Here, color was applied by whispering a sharp pencil over the paper's surface. With light pressure, the color is almost transparent.

Medium Pressure This middle range creates a good foundation for layering.

Heavy Pressure Pushing down on the pencil flattens the paper's texture, making the color appear almost soli

WATERCOLOR BASICS

Watercolor paint straight from the tube is generally too dry and thick to work with, so you'll need to dilute it with water. The less water you use, the more intense the color will be.

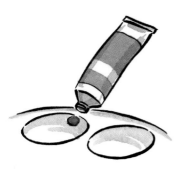

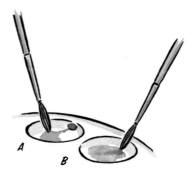

Starting Out Small Watercolors are very concentrated—a little goes a long way. Start by squeezing out a pea-sized amount of paint into one of the wells of your mixing palette.

Diluting the Paint Dip your brush in clean water, and then mix the water with the paint. Keep adding water until you achieve the dilution level you want (A). You also can transfer some of the paint to a separate well for mixing with other colors or for diluting the paint further (B).

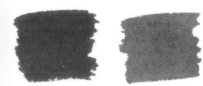

Dilution Chart Here's how brilliant red looks in four different dilution levels, from slightly diluted to very diluted.

TESTING YOUR COLORS
It's always a good idea to have a piece of scrap paper handy to test your colors before applying them to your painting.

Color Basics

Color can help bring your drawings to life, but first it helps to know a bit about color theory. There are three *primary* colors: red, yellow, and blue. These colors cannot be created by mixing other colors. Mixing two primary colors produces a *secondary* color: orange, green, and purple. Mixing a primary color with a secondary color produces a *tertiary* color: red-orange, red-purple, yellow-orange, yellow-green, blue-green, and blue-purple. Reds, yellows, and oranges are "warm" colors; greens, blues, and purples are "cool" colors.

THE COLOR WHEEL

A color wheel is useful for understanding relationships between colors. Knowing where each color is located on the color wheel makes it easy to understand how colors relate to and react with one another.

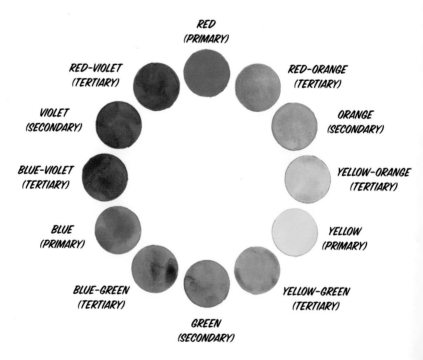

RED
(PRIMARY)

RED-VIOLET
(TERTIARY)

RED-ORANGE
(TERTIARY)

VIOLET
(SECONDARY)

ORANGE
(SECONDARY)

BLUE-VIOLET
(TERTIARY)

YELLOW-ORANGE
(TERTIARY)

BLUE
(PRIMARY)

YELLOW
(PRIMARY)

BLUE-GREEN
(TERTIARY)

YELLOW-GREEN
(TERTIARY)

GREEN
(SECONDARY)

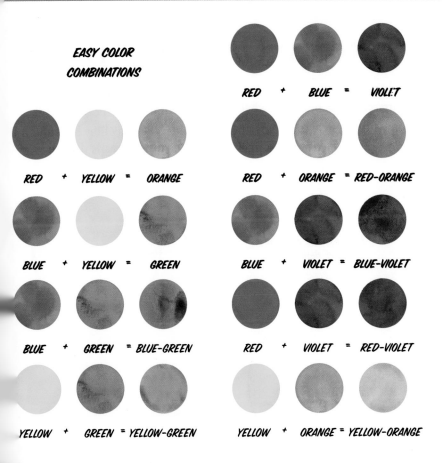

EASY COLOR COMBINATIONS

RED + BLUE = VIOLET

RED + YELLOW = ORANGE

RED + ORANGE = RED-ORANGE

BLUE + YELLOW = GREEN

BLUE + VIOLET = BLUE-VIOLET

BLUE + GREEN = BLUE-GREEN

RED + VIOLET = RED-VIOLET

YELLOW + GREEN = YELLOW-GREEN

YELLOW + ORANGE = YELLOW-ORANGE

BLENDING COLORED PENCILS

Colored pencils are transparent by nature, so instead of "mixing" colors as you would for painting, you create blends directly on the paper by layering colors on top of one another.

ADDING COLOR TO YOUR DRAWING

Some artists draw directly on illustration board or watercolor paper and then apply color directly to the original pencil drawing; however, if you are a beginning artist, you might opt to preserve your original pencil drawing by making several photocopies and applying color to a photocopy. This way, you'll always have your original drawing in case you make a mistake or you want to experiment with different colors or mediums.

How to Use This Book

Usually, artists draw characters in several steps. Sometimes the steps are different, depending on what you're drawing. The important thing to remember is to start simply and add details later. The blue lines show each new step, and the black lines show what you've already drawn.

THE FIRST THING YOU'LL DRAW ARE GUIDELINES TO HELP POSITION THE FEATURES OF THE CHARACTER.

1

2

NEXT YOU'LL START TO ADD DETAILS TO YOUR DRAWING. IT WILL TAKE SEVERAL STEPS TO ADD ALL THE DETAILS.

3

4

5

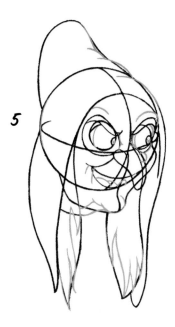

WHEN YOU FINISH ALL THE
DETAILS OF YOUR DRAWING,
YOU CAN GO BACK AND ERASE
YOUR GUIDELINES. YOU CAN
ALSO DARKEN YOUR LINES WITH
A PEN OR MARKER.

6

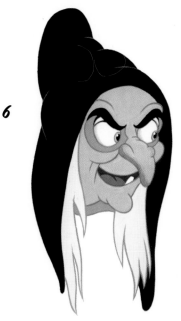

NOW ADD COLOR!

PETE

Pete is never up to any good—his only goal is to aggravate
Mickey Mouse and his friends.

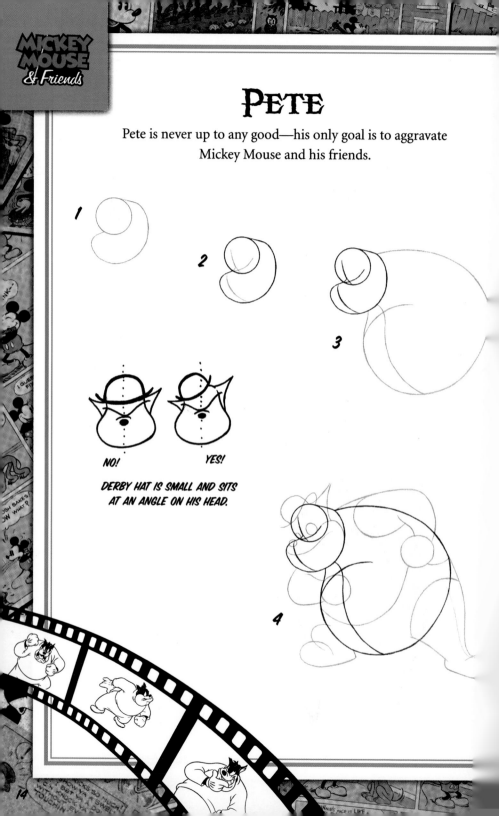

NO!　　　　YES!

DERBY HAT IS SMALL AND SITS
AT AN ANGLE ON HIS HEAD.

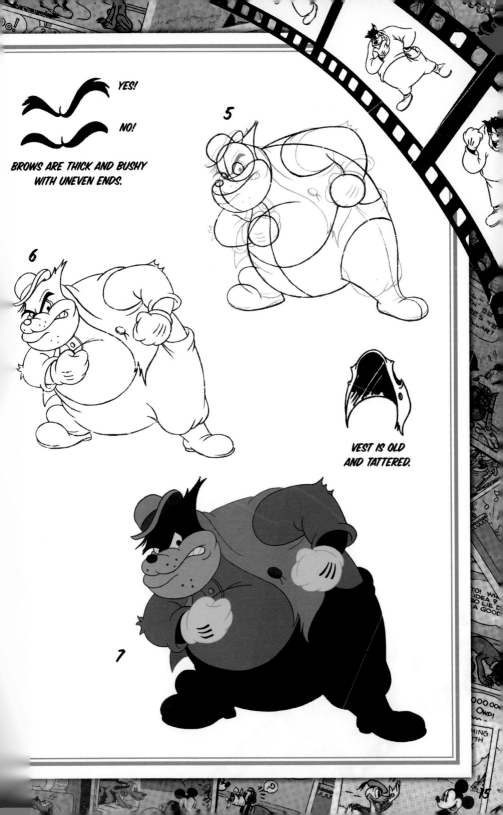

YES!

NO!

BROWS ARE THICK AND BUSHY WITH UNEVEN ENDS.

5

6

VEST IS OLD AND TATTERED.

7

CAPTAIN HOOK

Captain Hook is no longer sailing the seas looking for treasure as a fearsome pirate. Instead, he's hunting down Peter Pan, and he won't stop until he has revenge.

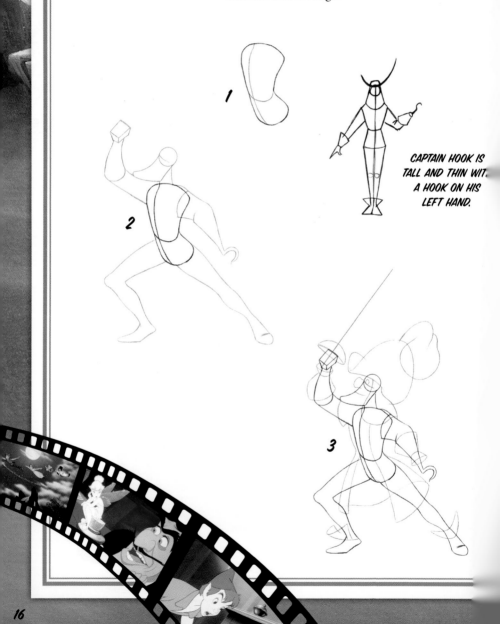

CAPTAIN HOOK IS TALL AND THIN WITH A HOOK ON HIS LEFT HAND.

1

2

3

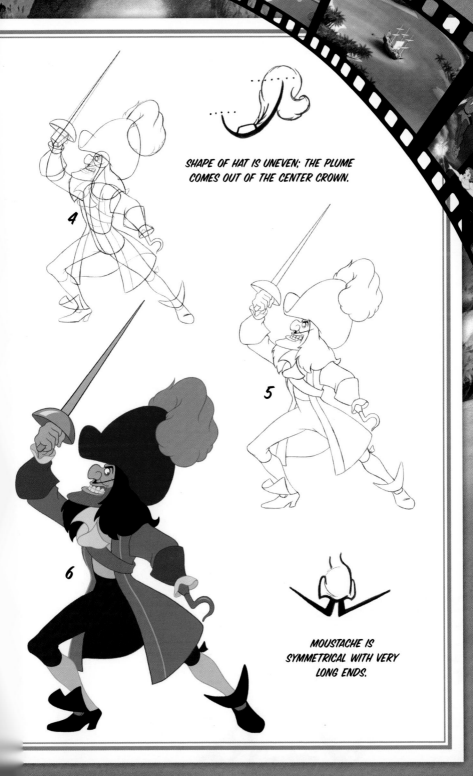

SHAPE OF HAT IS UNEVEN; THE PLUME COMES OUT OF THE CENTER CROWN.

4

5

6

MOUSTACHE IS SYMMETRICAL WITH VERY LONG ENDS.

Sí and Am

This destructive duo is always looking to cause trouble.
Don't forget to include their crooked tails and exposed teeth.

1

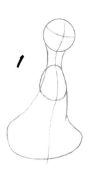 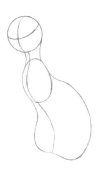

**CAT HEAD STARTS
WITH AN OVAL.**

**DOG HEAD STARTS
WITH A CIRCLE.**

2

3

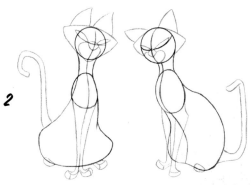

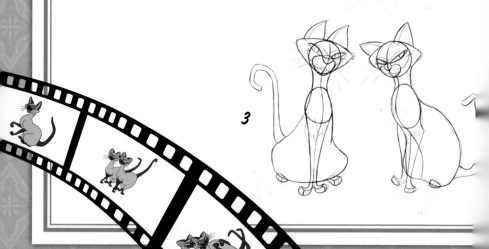

SI AND AM HAVE THREE WHISKERS ON
EACH SIDE OF THE FACE.

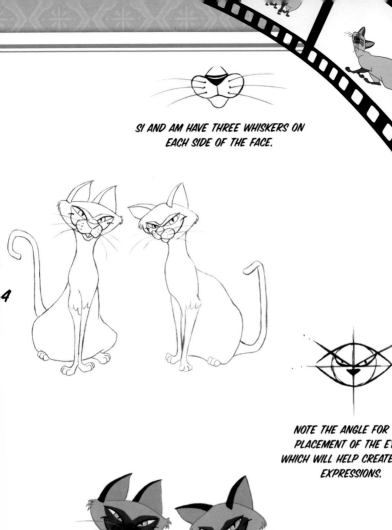

4

NOTE THE ANGLE FOR THE
PLACEMENT OF THE EYES,
WHICH WILL HELP CREATE THEIR
EXPRESSIONS.

5

MALEFICENT

Maleficent is the most powerful fairy in the land. She embodies pure wickedness, and she even refers to herself as "the mistress of all evil." The folds of her robe trail behind her, so make sure to capture that detail in your drawing.

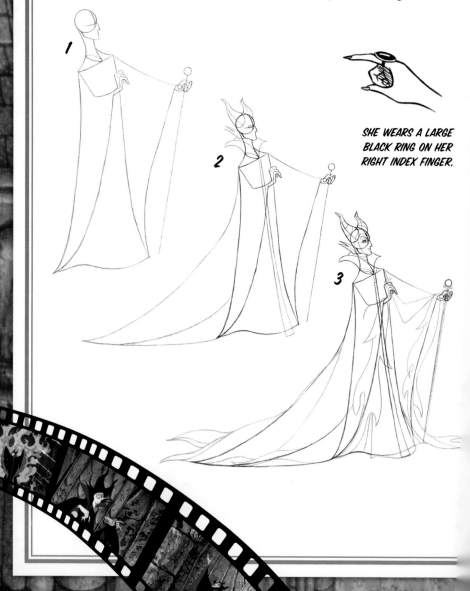

SHE WEARS A LARGE BLACK RING ON HER RIGHT INDEX FINGER.

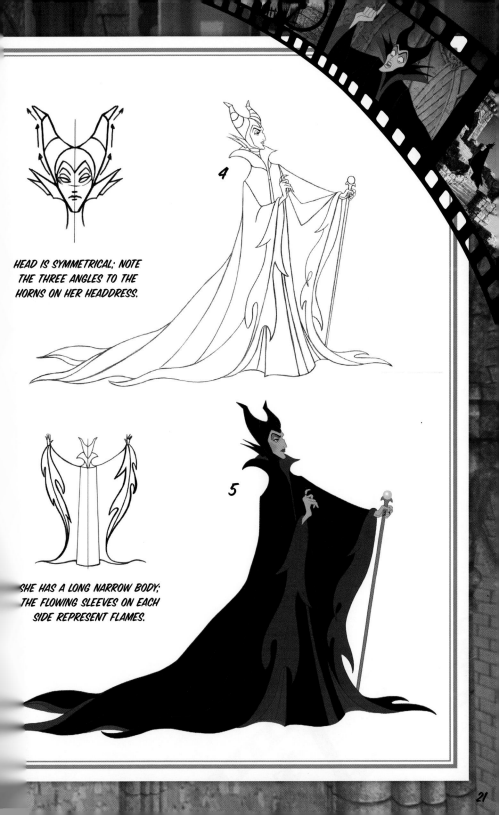

HEAD IS SYMMETRICAL; NOTE THE THREE ANGLES TO THE HORNS ON HER HEADDRESS.

4

5

SHE HAS A LONG NARROW BODY; THE FLOWING SLEEVES ON EACH SIDE REPRESENT FLAMES.

BIG BAD WOLF

Who's afraid of drawing the Big Bad Wolf? Not you. Just focus on the details: his claws, his teeth, the tattered hem of his trousers, and the wrinkles in his snout.

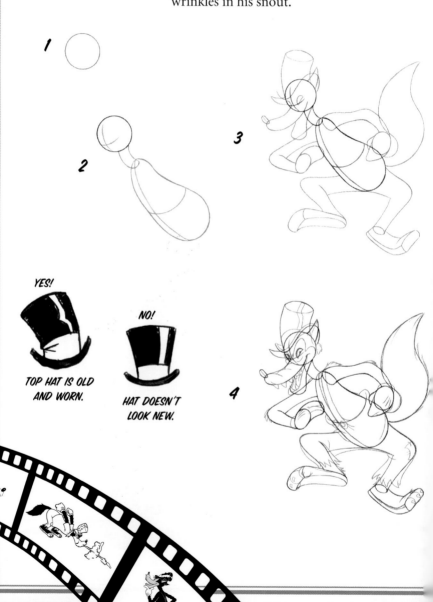

1

2

3

YES!

TOP HAT IS OLD
AND WORN.

NO!

HAT DOESN'T
LOOK NEW.

4

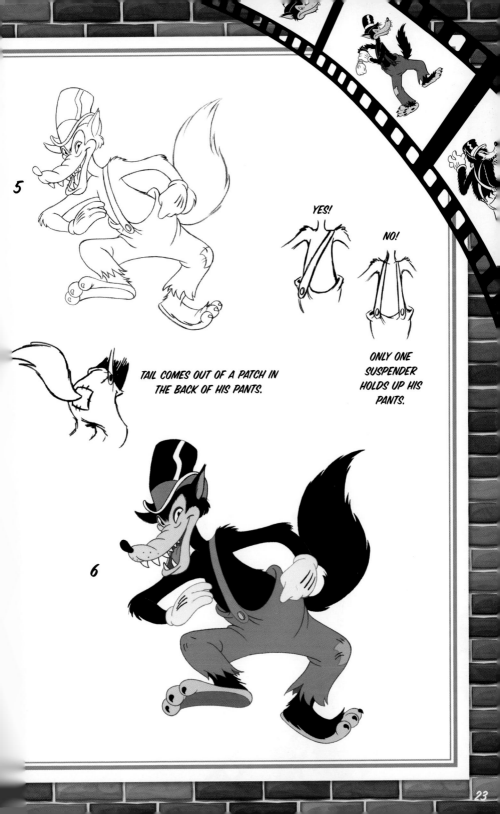

5

YES!

NO!

TAIL COMES OUT OF A PATCH IN
THE BACK OF HIS PANTS.

ONLY ONE
SUSPENDER
HOLDS UP HIS
PANTS.

6

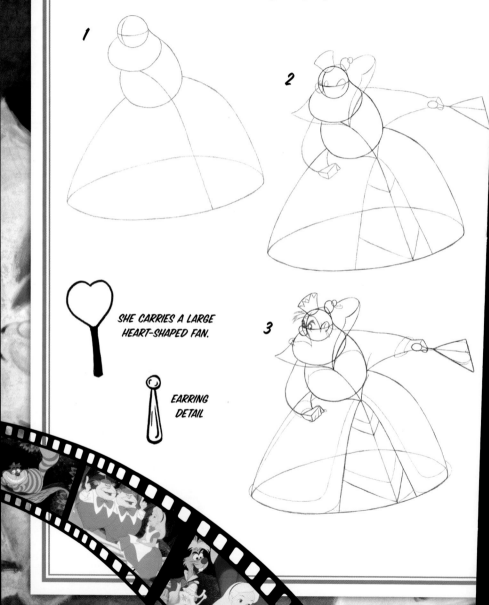

QUEEN OF HEARTS

The Queen of Hearts always looks aggravated, annoyed, and just plain mad. She is a larger-than-life villain wearing a tiny crown. As you draw her, keep her proportions intact.

1

2

SHE CARRIES A LARGE
HEART-SHAPED FAN.

EARRING
DETAIL

3

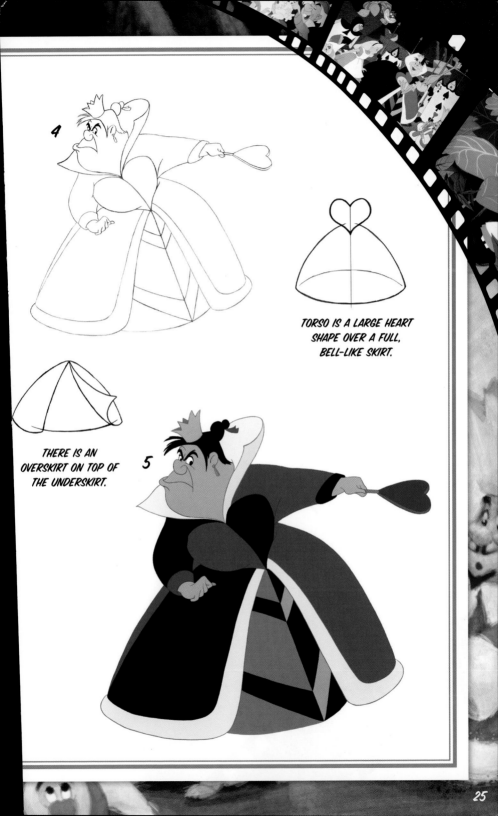

4

TORSO IS A LARGE HEART SHAPE OVER A FULL, BELL-LIKE SKIRT.

THERE IS AN OVERSKIRT ON TOP OF THE UNDERSKIRT.

5

LUCÍFER

Lucifer is a truly devilish cat—and the favorite pet of Cinderella's evil stepmother, Lady Tremaine. As you draw Lucifer, keep his nails sharp, his eyes watchful, and his tail fluffy.

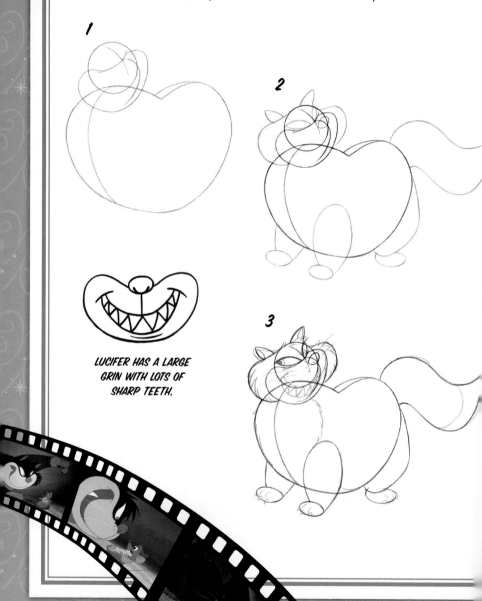

1

2

3

LUCIFER HAS A LARGE GRIN WITH LOTS OF SHARP TEETH.

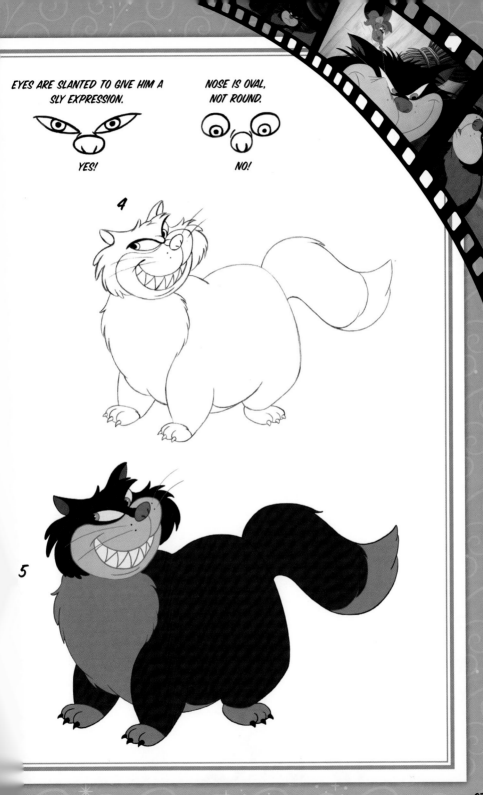

EYES ARE SLANTED TO GIVE HIM A SLY EXPRESSION.

YES!

NOSE IS OVAL, NOT ROUND.

NO!

4

5

CRUELLA DE VIL

Cruella de Vil is obsessed with fur coats. So much so, that she steals Dalmatian puppies for their fur so she can make one. It doesn't get more evil than that! She has a striking profile, with a slender frame, pronounced jaw, and eyes full of menace.

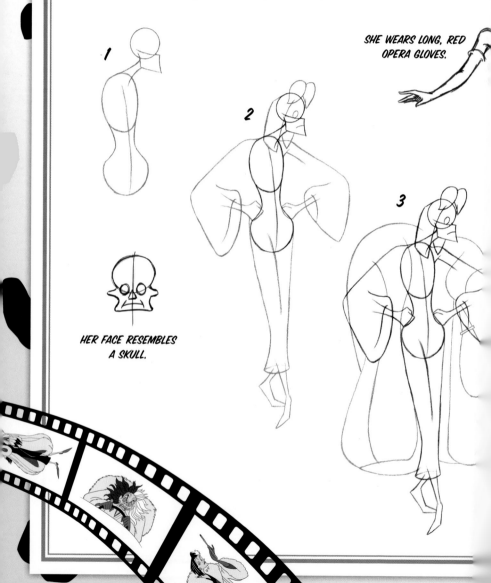

SHE WEARS LONG, RED OPERA GLOVES.

HER FACE RESEMBLES A SKULL.

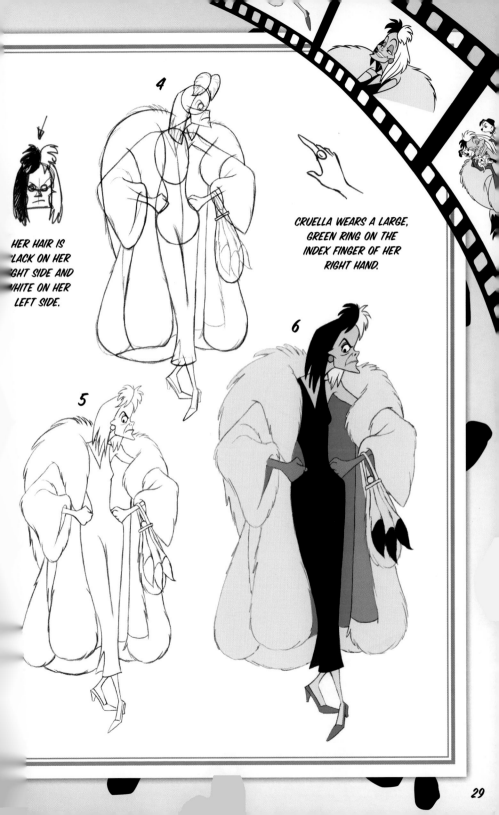

4

HER HAIR IS
BLACK ON HER
RIGHT SIDE AND
WHITE ON HER
LEFT SIDE.

CRUELLA WEARS A LARGE,
GREEN RING ON THE
INDEX FINGER OF HER
RIGHT HAND.

5

6

URSULA

This view of Ursula's head shows the depth of her full face. The flame-like shape of her hair frames her face and suggests her evil mind.

1

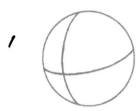

2

ALTHOUGH URSULA'S HEAD IS SMALL, HER JAWLINE IS VERY WIDE. ANGULAR OVALS CREATE HER EYES AND EYEBROWS.

3

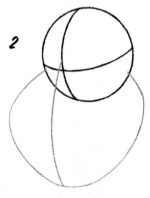

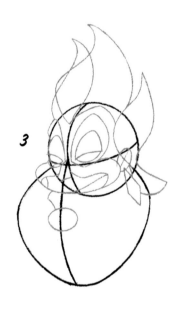

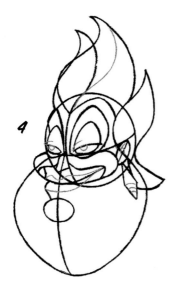

4

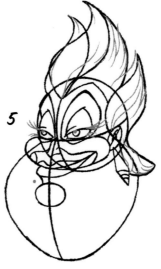

5

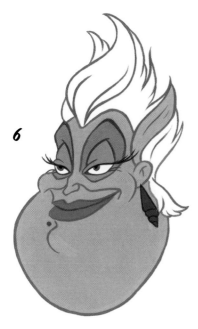

6

DON'T FORGET URSULA'S "BEAUTY" MARK.

URSULA

Ursula manipulates everyone to get what she wants. Even though she steals Ariel's voice, she never steals the song in Ariel's heart.

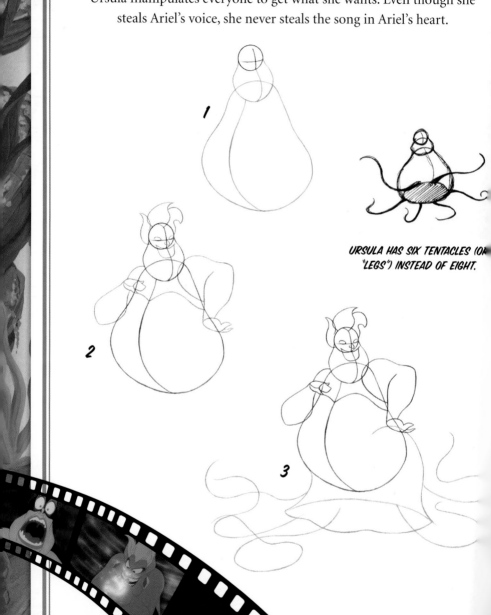

URSULA HAS SIX TENTACLES (OR "LEGS") INSTEAD OF EIGHT.

1

2

3

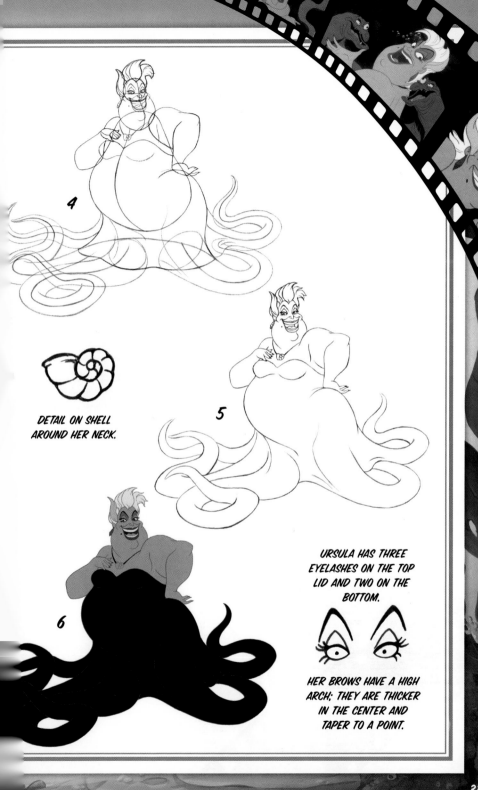

4

DETAIL ON SHELL
AROUND HER NECK.

5

6

URSULA HAS THREE
EYELASHES ON THE TOP
LID AND TWO ON THE
BOTTOM.

HER BROWS HAVE A HIGH
ARCH; THEY ARE THICKER
IN THE CENTER AND
TAPER TO A POINT.

FLOTSAM AND JETSAM

These two eels are Ursula's minions who spy, steal, and trick others on her behalf.

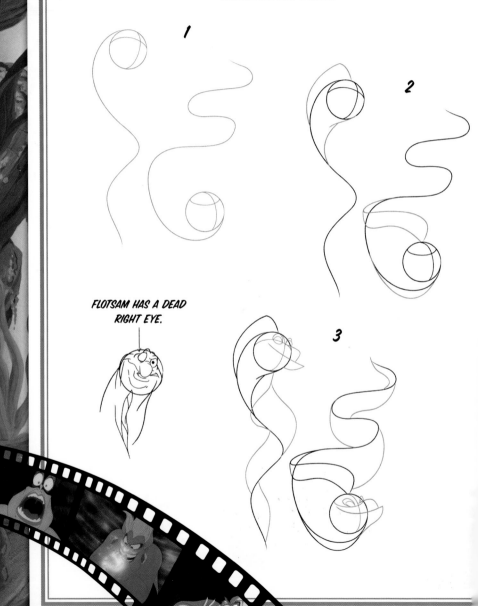

1

2

3

FLOTSAM HAS A DEAD
RIGHT EYE.

4

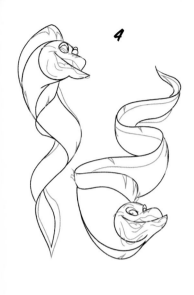

5

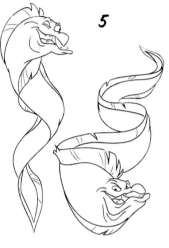

6

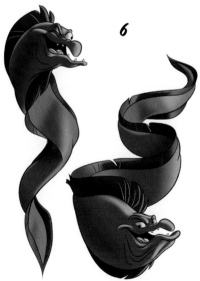

JETSAM HAS A DEAD
LEFT EYE.

JAFAR

The evil Jafar has a long, narrow face that always seems to be sneering. Try to capture his cruel nature when drawing his face.

1

2

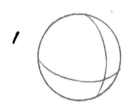

3

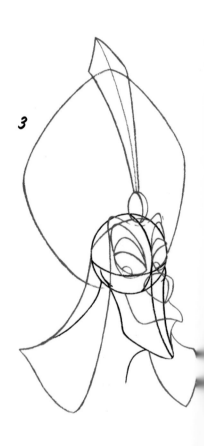

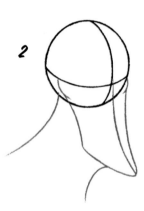

THE BALL OF JAFAR'S HEAD IS SMALL, WITH A LONG, ANGULAR JAW.

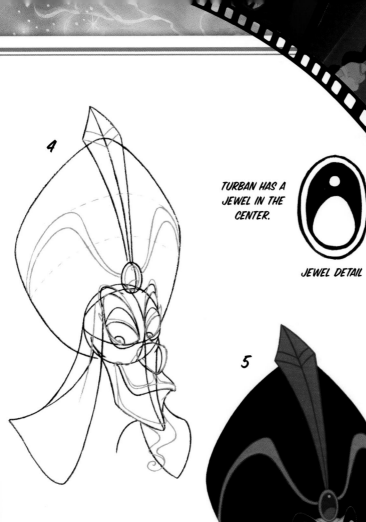

4

TURBAN HAS A
JEWEL IN THE
CENTER.

JEWEL DETAIL

5

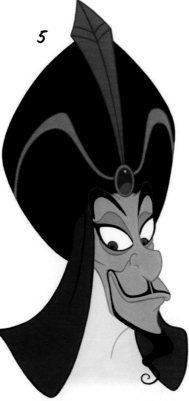

JAFAR

Jafar appears to be a wise counselor to the Sultan, but he really wants the throne for himself, and wills all of his power to achieve it—until Aladdin gets in his way. Jafar is tall, thin, and stands above everyone. Remember to focus on the little details, such as his curlicue goatee and cobra-head staff.

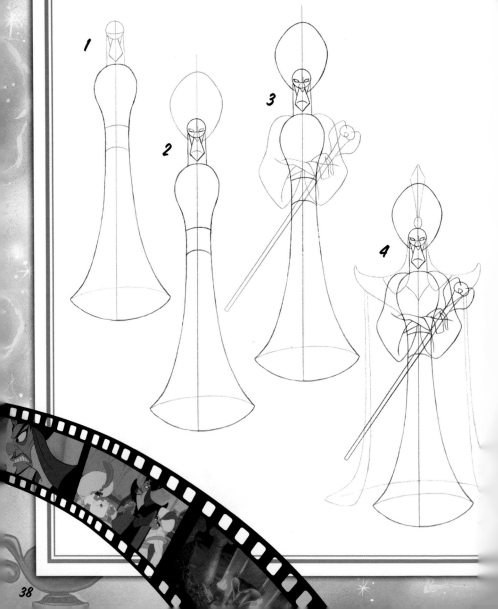

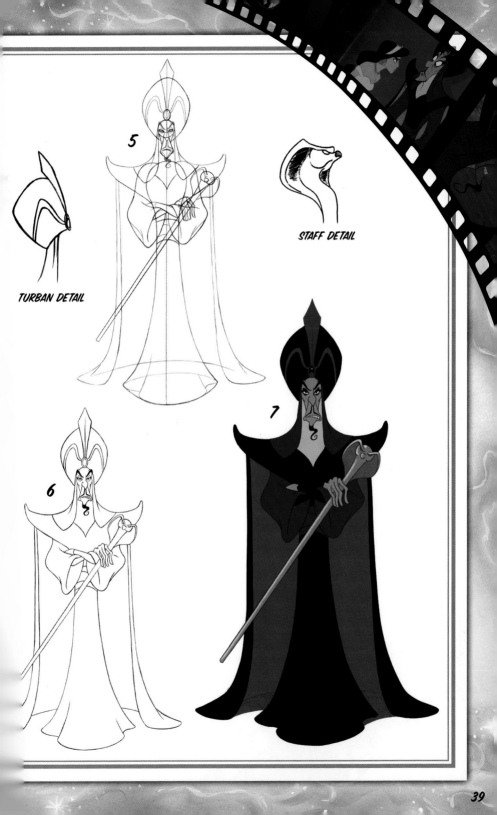

TURBAN DETAIL

STAFF DETAIL

5

6

7

IAGO

Iago is Jafar's squawking, magical sidekick, but it's hard to tell whose side he's really on. Sometimes, he does Jafar's dirty work; other times, he helps Jasmine out of a bind.

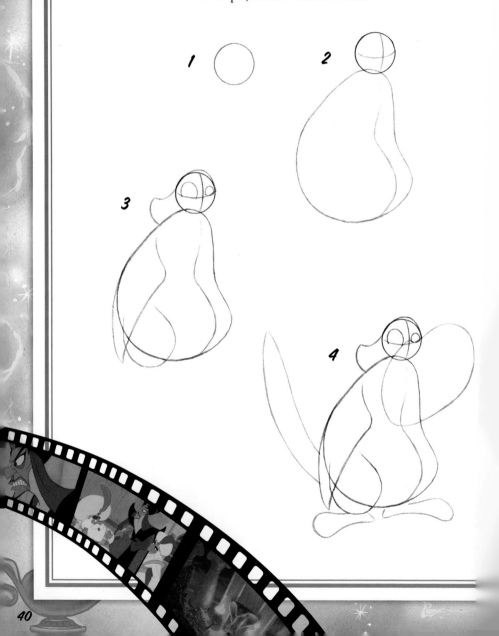

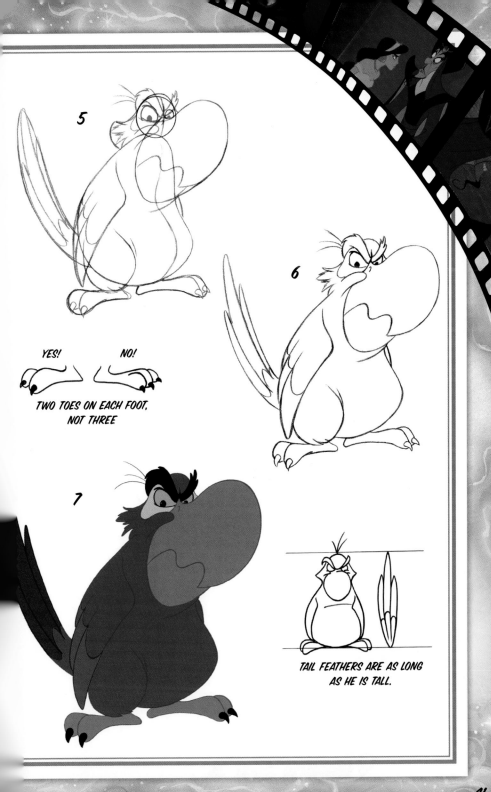

5

6

YES! NO!

TWO TOES ON EACH FOOT,
NOT THREE

7

TAIL FEATHERS ARE AS LONG
AS HE IS TALL.

THE QUEEN

The regal Queen is an aristocratic, strong-willed beauty.
But her diabolically evil nature clearly shows through in her expressions.

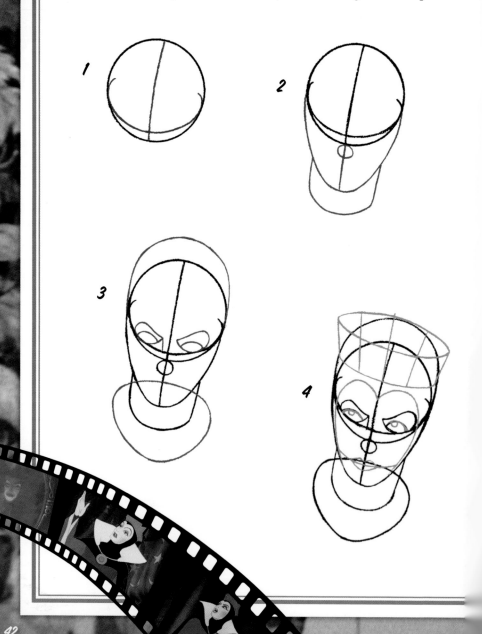

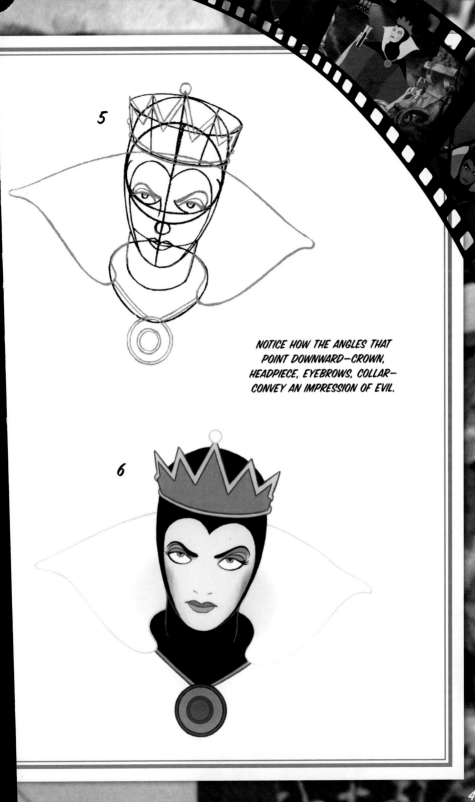

5

NOTICE HOW THE ANGLES THAT POINT DOWNWARD—CROWN, HEADPIECE, EYEBROWS, COLLAR—CONVEY AN IMPRESSION OF EVIL.

6

THE QUEEN

Standing before the world, the Queen appears to be a regal beauty.
But at her core, she is an evil villain determined to destroy Snow White.

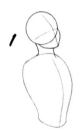

**EYE SHAPE IS ALMOND—NOT ROUND;
LASHES CURL UP SOFTLY.**

YES! NO!

**BROW IS S-SHAPED; IT'S THICK
ON THE INSIDE EDGE AND
TAPERS OUT TO A THIN LINE.**

NO!

YES!

**THE CROWN CURVES
OVER HER HEAD AND
HAS A THICKER EDGE
ON TOP AND BOTTOM.**

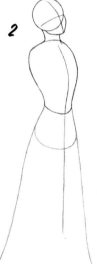

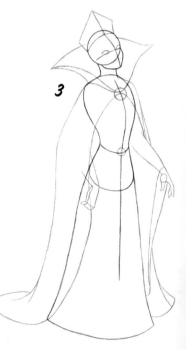

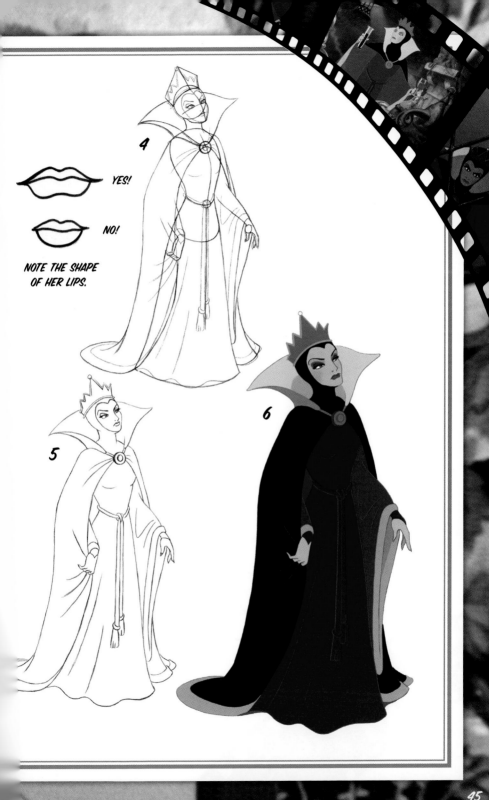

YES!

NO!

NOTE THE SHAPE
OF HER LIPS.

4

5

6

THE WITCH

When the evil Queen transforms herself to trick Snow White,
she reveals the true ugliness of her character.
Draw her with bulging eyes and a pointed chin.

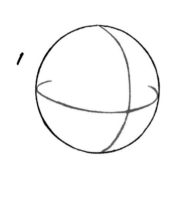

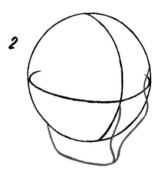

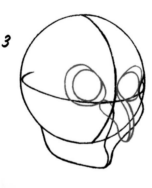

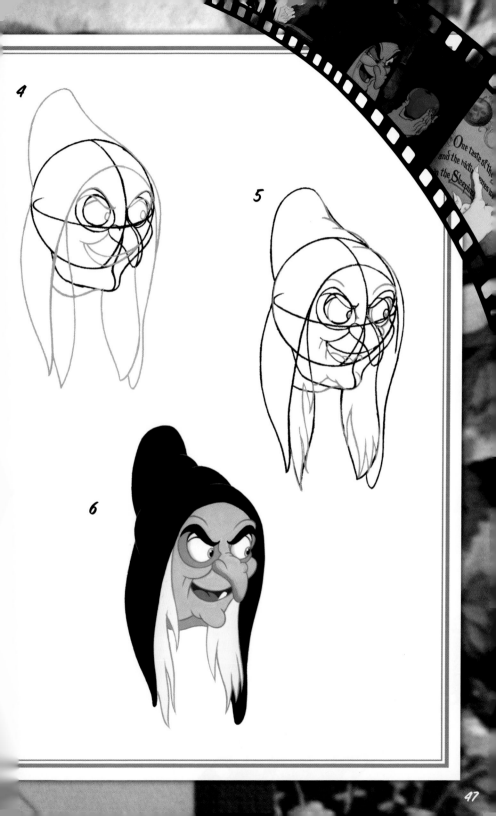

4

5

6

THE WITCH

The Witch uses her power to trick Snow White into taking a poison apple. Try to capture the Witch's evil look in your drawing, and don't forget to make that apple look tempting and delicious!

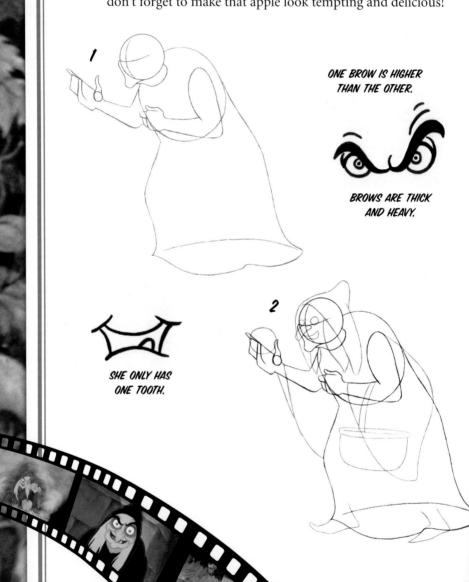

1

ONE BROW IS HIGHER THAN THE OTHER.

BROWS ARE THICK AND HEAVY.

SHE ONLY HAS ONE TOOTH.

2

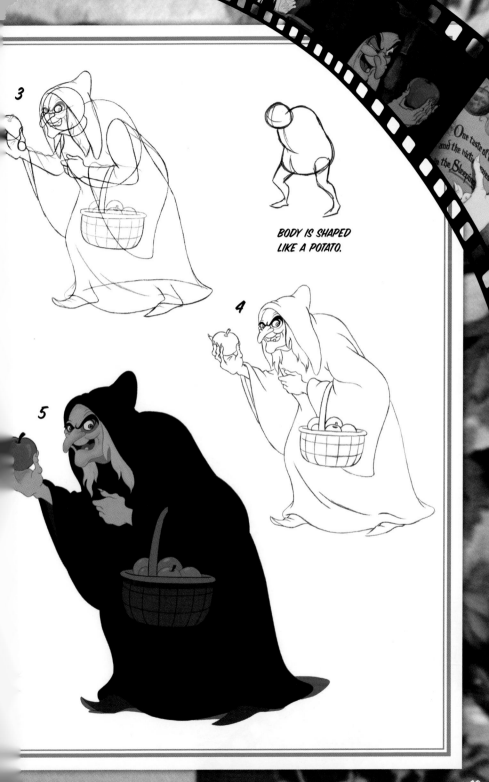

3

BODY IS SHAPED
LIKE A POTATO.

4

5

SCAR

The wicked Scar has a large nose and small eyes. His mane is darker and wilder than the other lions' manes, and his mouth curves in an evil grin.

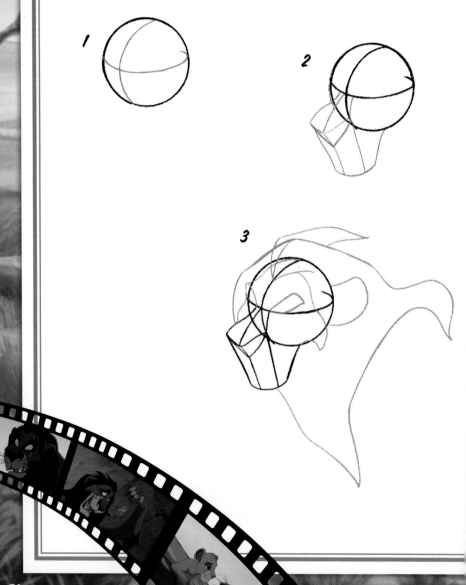

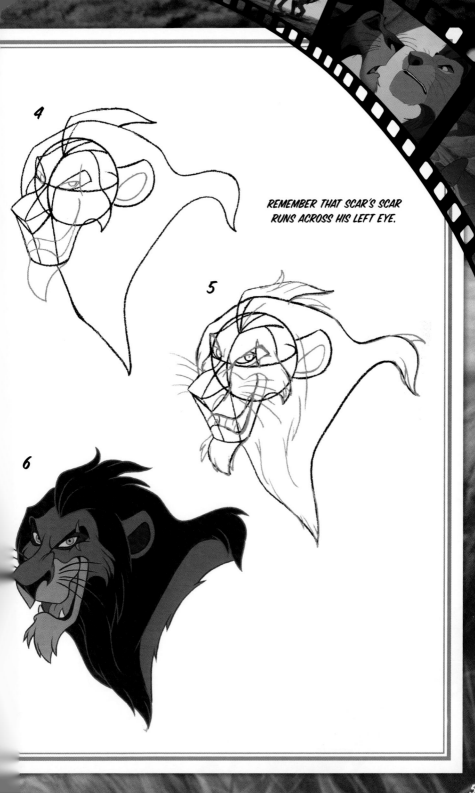

4

5

6

REMEMBER THAT SCAR'S SCAR
RUNS ACROSS HIS LEFT EYE.

SCAR

Scar has a long, lean body and large paws with the claws extended.
These features underscore his sinister nature.

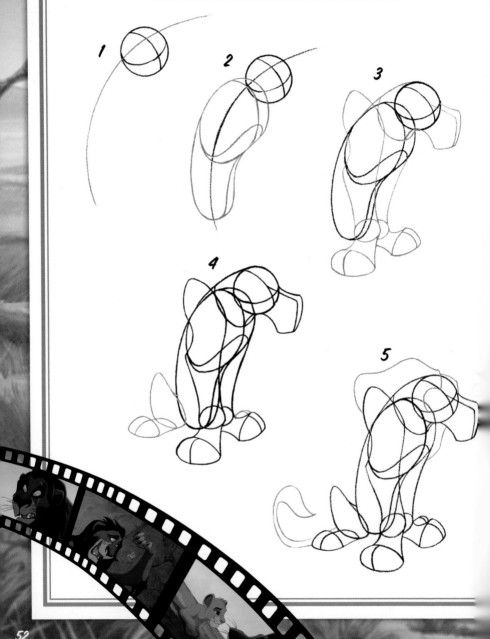

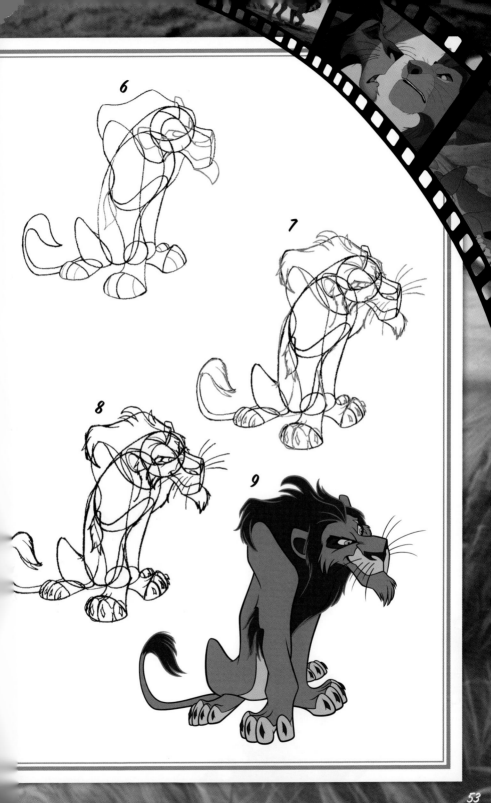

6

7

8

9

THE HYENAS

The hyenas, Shenzi, Banzai, and Ed, prey upon young Simba and Nala. Notice how their eyes give away their individual personalities.

BANZAI

BANZAI'S EYES ARE TWO DIFFERENT SHAPES—ONE IS SLIGHTLY NARROWED.

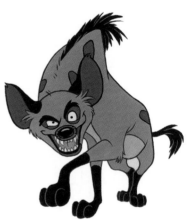

2

ED

ED'S EARS ARE NOTCHED.

SHENZI

SHENZI HAS A SMALL "MANE" ON THE TOP OF HER HEAD.

3

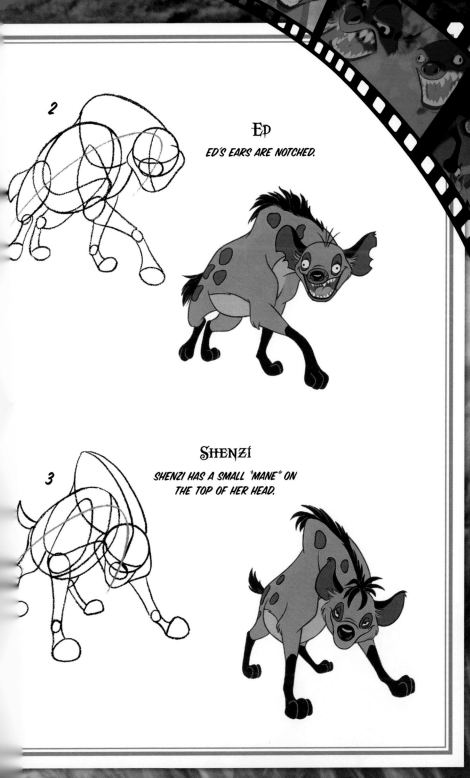

MOTHER GOTHEL

Mother Gothel is young and beautiful—all because of Rapunzel's hair. Her wicked ways show her ugly side in her stance, her expressions, and her cruel comments.

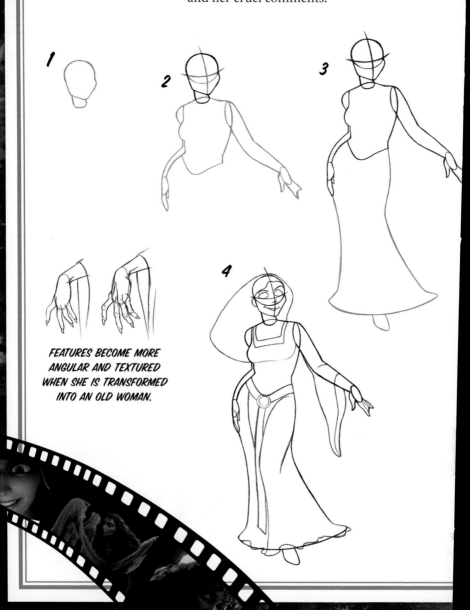

1

2

3

4

FEATURES BECOME MORE
ANGULAR AND TEXTURED
WHEN SHE IS TRANSFORMED
INTO AN OLD WOMAN.

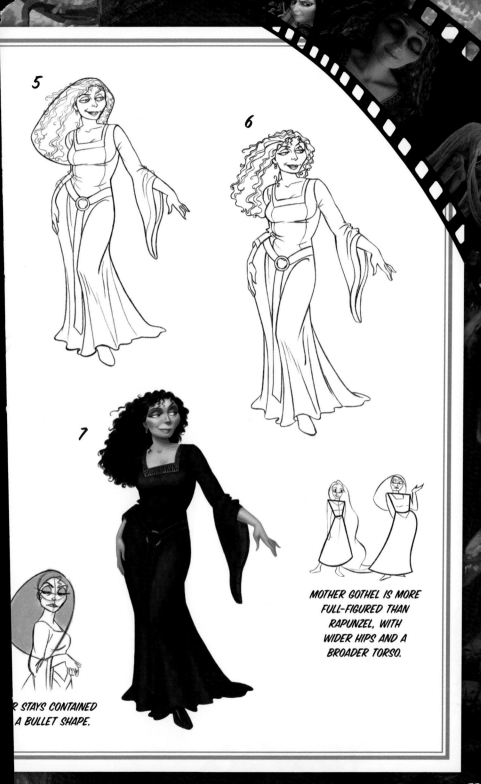

5

6

7

MOTHER GOTHEL IS MORE
FULL-FIGURED THAN
RAPUNZEL, WITH
WIDER HIPS AND A
BROADER TORSO.

R STAYS CONTAINED
A BULLET SHAPE.

DR. FACILIER

Dr. Facilier is a sinister and charismatic man of dark magic who works in the French Quarter. He yearns to expand his small-time business so he can spread darkness and corruption throughout New Orleans…and become fantastically wealthy in the process.

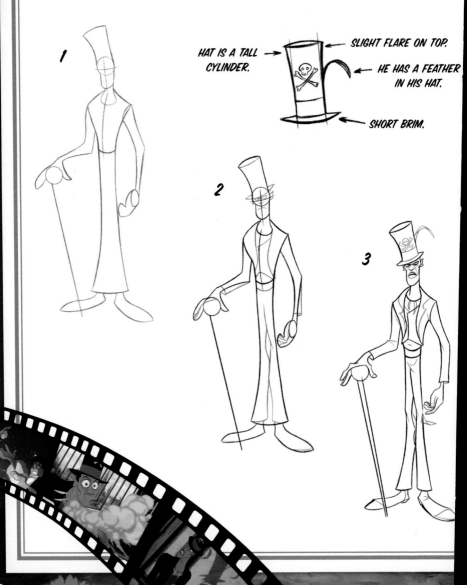

1

HAT IS A TALL CYLINDER.

SLIGHT FLARE ON TOP.

HE HAS A FEATHER IN HIS HAT.

SHORT BRIM.

2

3

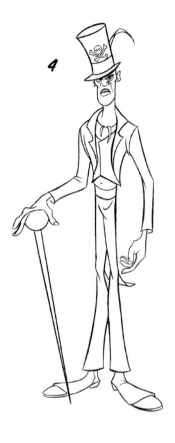

4

YES!
EAR SHAPE IS
MORE ANGULAR.

NO!
TOO
ROUND

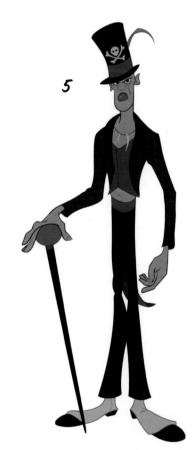

5

YES! MOUSTACHE IS
PENCIL THIN.

NO! NOT TOO LARGE.

LAWRENCE

Lawrence is Naveen's stiff, pompous, roly-poly valet. Though he plays the part of the prince's dutiful manservant, Lawrence is secretly envious of the Prince's charm, good looks, and position.

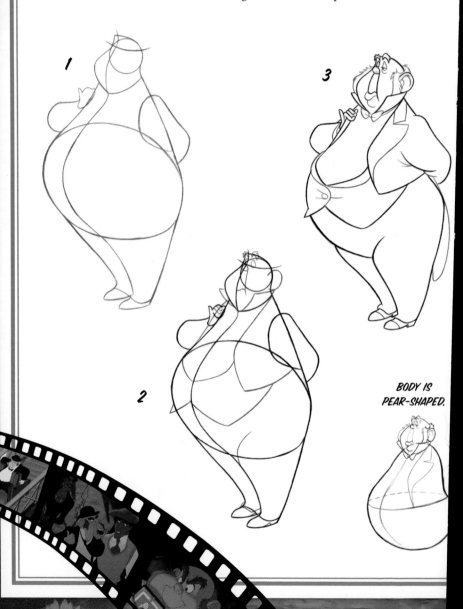

1

2

3

BODY IS PEAR-SHAPED.

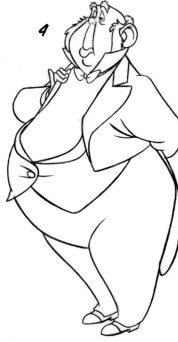

4

NOSE IS ROUND
AND UPTURNED.

YES! NO! NO!

5

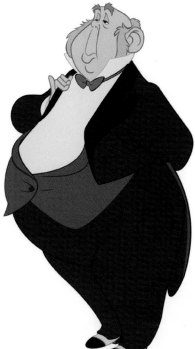

MOUTH SITS LOW
ON THE FACE.

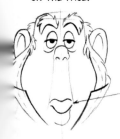

LARGE
LOWER
LIP.

ZURG

The Universe—and Al's Toy Barn—is not safe with the evil Emperor Zurg on the loose. Zurg is smart enough to escape from the store and strong enough to take on Buzz and New Buzz, but he's unlucky enough to be on the receiving end of Rex's swinging tail.

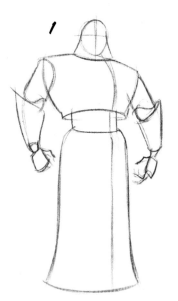

5 TORSO RINGS.

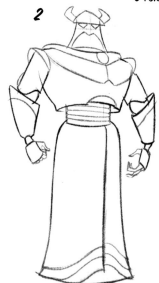

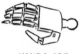

HANDS ARE COMPOSED OF SHARP STEEL PARTS WITH CLAW-LIKE FINGERS.

FINGERS RESEMBLE ARMOR PLATES.

VISOR APPEAR TRIANGULAR I ALL VIEWS.

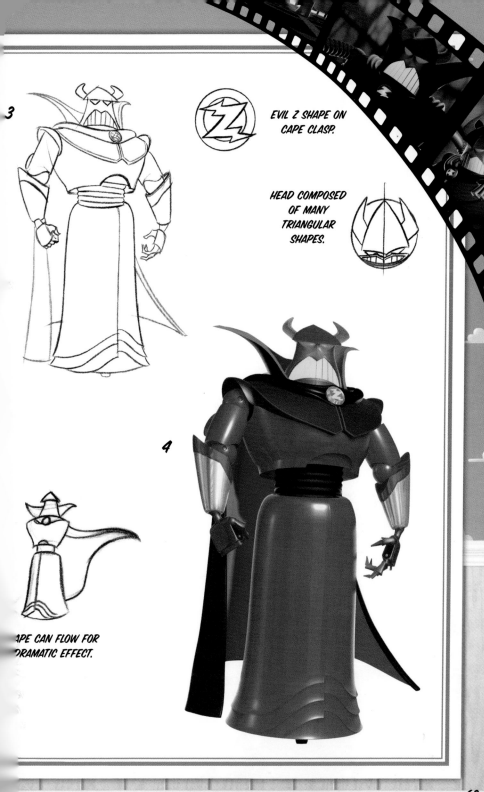

3

EVIL Z SHAPE ON
CAPE CLASP.

HEAD COMPOSED
OF MANY
TRIANGULAR
SHAPES.

4

...APE CAN FLOW FOR
...DRAMATIC EFFECT.

THE PROSPECTOR

The Prospector may seem like a nice grandfatherly type of fellow at first, but when his true feelings are revealed, it becomes clear that he's just plain selfish and mean. Having never belonged to a child, the Prospector simply doesn't know how to play—or be loved.

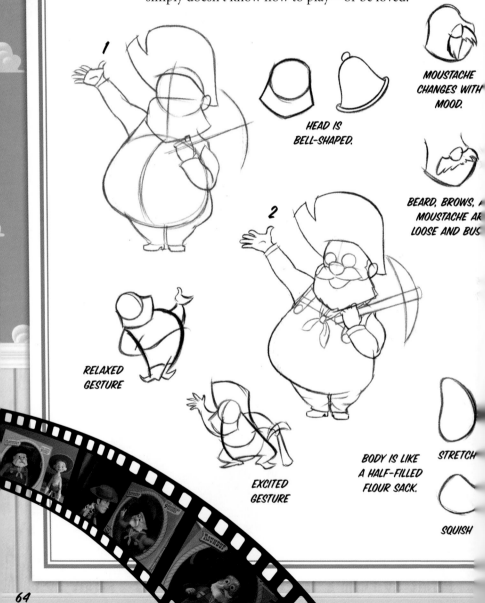

1

MOUSTACHE CHANGES WITH MOOD.

HEAD IS BELL-SHAPED.

BEARD, BROWS, MOUSTACHE AR LOOSE AND BUS

2

RELAXED GESTURE

EXCITED GESTURE

BODY IS LIKE A HALF-FILLED FLOUR SACK.

STRETCH

SQUISH

3

THE PROSPECTOR IS NEVER WITHOUT HIS PICKAX.

BUTTON DETAIL

BOOT FLARES AT TOP.

AT CURLS UP IN RONT AND BACK.

POINTY BEARD IN IDE VIEW

4

SMALL HANDS WITH SLENDER FINGERS

TIGHT-FITTING SLEEVES

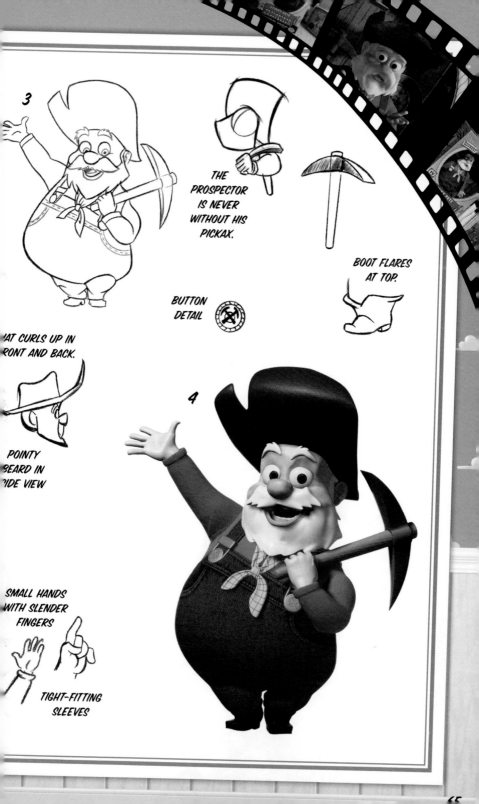

LOTSO

In *Toy Story 3*, Lots-o'-Huggin' Bear—a.k.a. Lotso—seems like nothing more than the nicest teddy bear at Sunnyside Daycare. But Lotso's true colors are exposed when he traps Andy's toys in the Caterpillar Room with all of the rambunctious toddlers—and later when he leaves the toys to be incinerated at the garbage dump.

1

EYEBROWS ARE WIDE AND BUSHY.

YES!

NO!

EARS ARE TWO HALF CIRCLES.

NOSE IS AN UPSIDE-DOWN ROUNDED TRIANGLE.

TEARDROP-SHAPED PAWS

2

3

EYES ARE ROUND AND SET CLOSE TOGETHER.

HIS CANE IS A WOODEN MALLET.

4

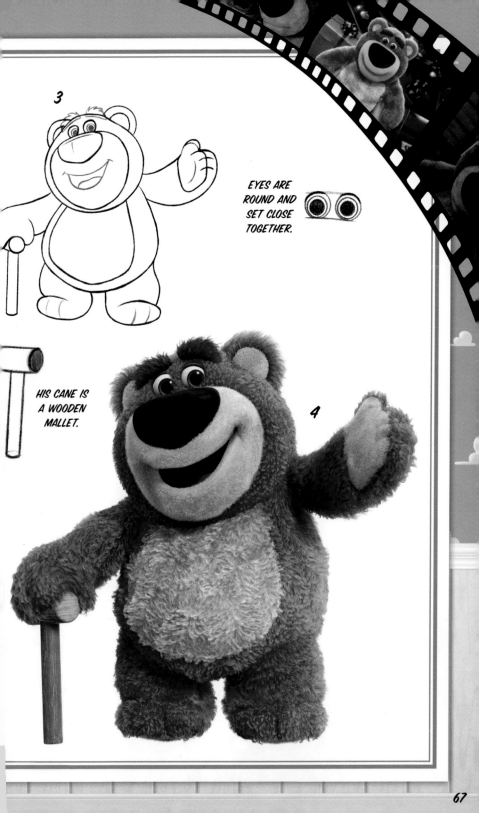

CHUNK

One of Lotso's cronies at Sunnyside Daycare, Chunk is a two-faced plasti
rock monster who goes from friendly to foul with the punch of a button

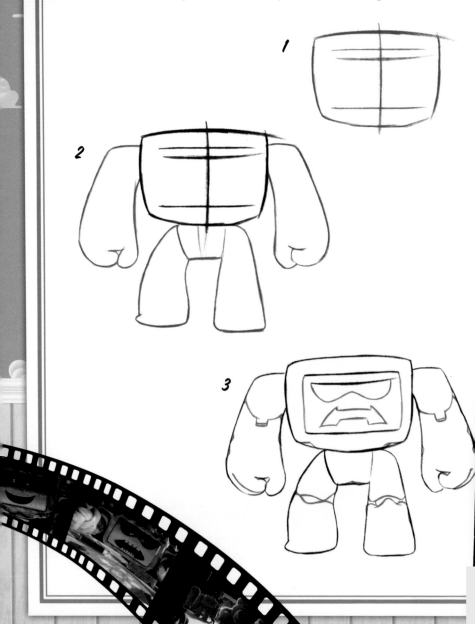

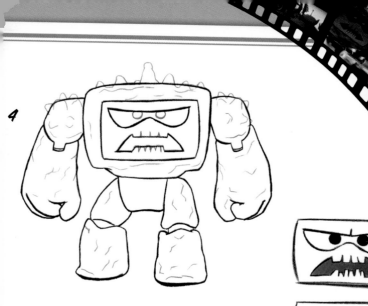

4

CHUNK HAS TWO FACES.

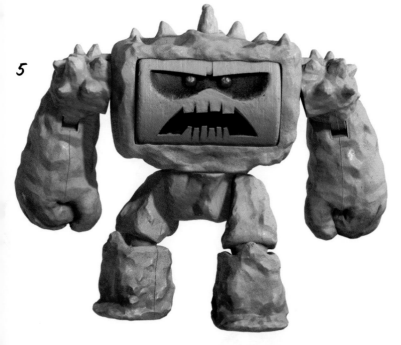

5

WATERNOOSE

Henry J. Waternoose's family has been in the scream-collecting business for three generations, and this large, crablike monster is not about to let something like an energy crisis bring down his company, Monsters, Inc.

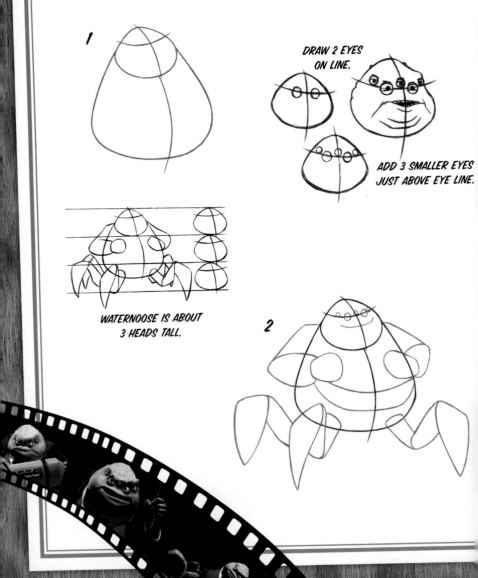

DRAW 2 EYES
ON LINE.

ADD 3 SMALLER EYES
JUST ABOVE EYE LINE.

WATERNOOSE IS ABOUT
3 HEADS TALL.

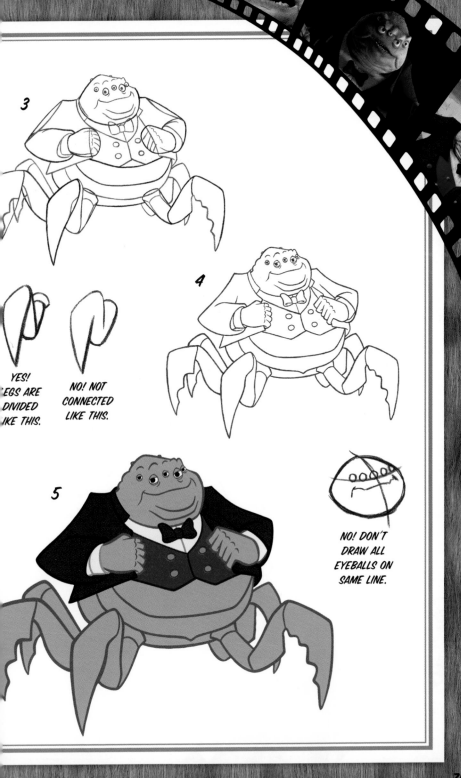

3

4

5

YES! LEGS ARE DIVIDED LIKE THIS.

NO! NOT CONNECTED LIKE THIS.

NO! DON'T DRAW ALL EYEBALLS ON SAME LINE.

RANDALL

Sneaky, creepy, sly, and sleazy, Randall Boggs is determined to do anything to become the top Scarer at Monsters, Inc.

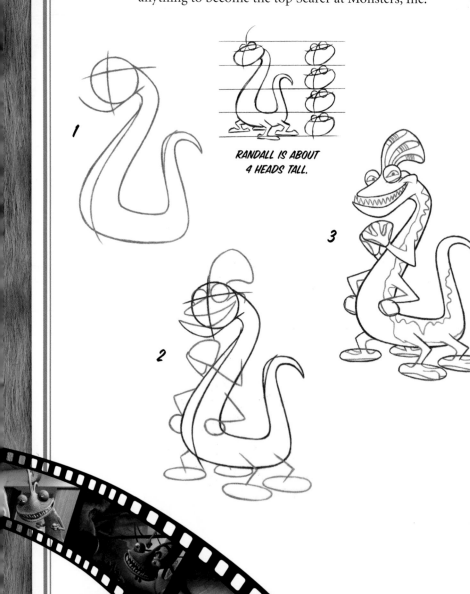

RANDALL IS ABOUT
4 HEADS TALL.

1

2

3

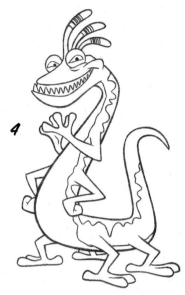

4

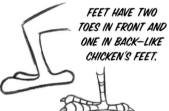

FEET HAVE TWO TOES IN FRONT AND ONE IN BACK—LIKE CHICKEN'S FEET.

YES! FRONDS ARE ROUNDED LIKE THIS.

NO! NOT POINTED LIKE THIS.

5

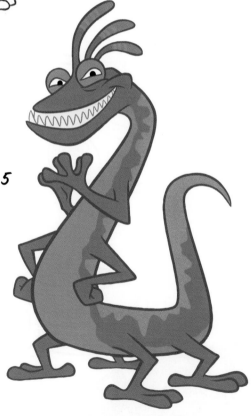

CHICK

Chick is a racing veteran with a chip on his shoulder. He's a ruthless competitor who is notorious for cheating his way to second place. Always a runner-up, he'll do anything to win.

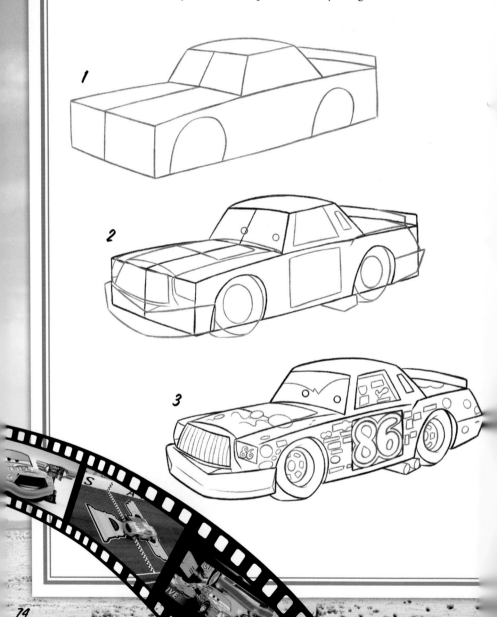

1

2

3

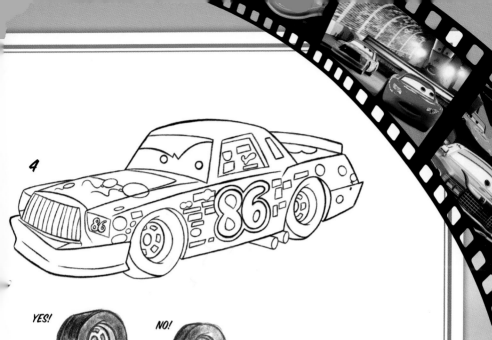

4

YES!

TIRES ARE BIG AND WIDE.

NO!

NOT TOO THIN.

5

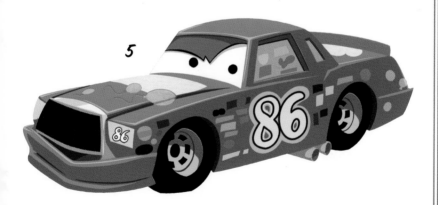

YES!

NO!

CHICK HAS BEADY
PUPILS AND A SHARP PEAK
BETWEEN HIS EYES.

PROFESSOR Z

The savvy mad scientist Professor Z has mastered the art of sophisticated weapons design and has created an elaborate device disguised as a camera that can harm cars without leaving a trace of evidence. His goal—to sabotage the World Grand Prix racers.

PROFESSOR Z IS REALLY SMALL.

PROFESSOR Z LOOKS THE SAME COMING OR GOING!

HIS BROKEN ROOF RACK GIVES THE APPEARANCE OF A HAIR COMB-OVER.

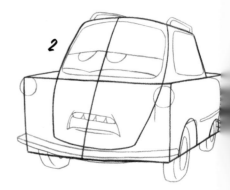

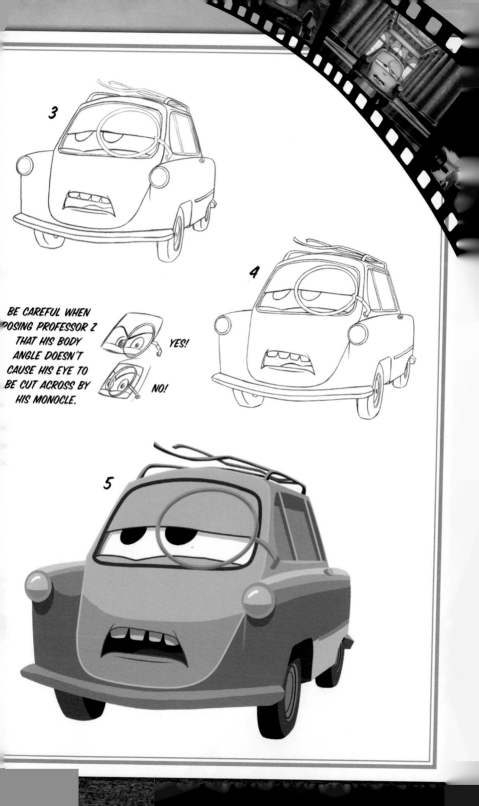

3

4

5

BE CAREFUL WHEN
POSING PROFESSOR Z
THAT HIS BODY
ANGLE DOESN'T
CAUSE HIS EYE TO
BE CUT ACROSS BY
HIS MONOCLE.

YES!

NO!

MILES AXLEROD

Sir Miles Axlerod has devoted his life and fortune—acquired as an oil baron—to creating a renewable, alternative fuel called Allinol. Mater and his friends soon discover that Allinol isn't all it's cracked up to be—and neither is Axlerod.

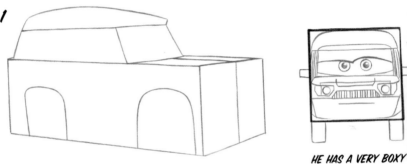

1

HE HAS A VERY BOXY
APPEARANCE FROM
THE FRONT.

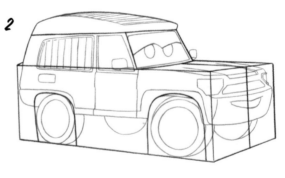

2

THE TOP OF HIS CAB
SHOULD RESEMBLE AN
ENGLISH DRIVING CAP.

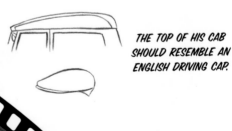

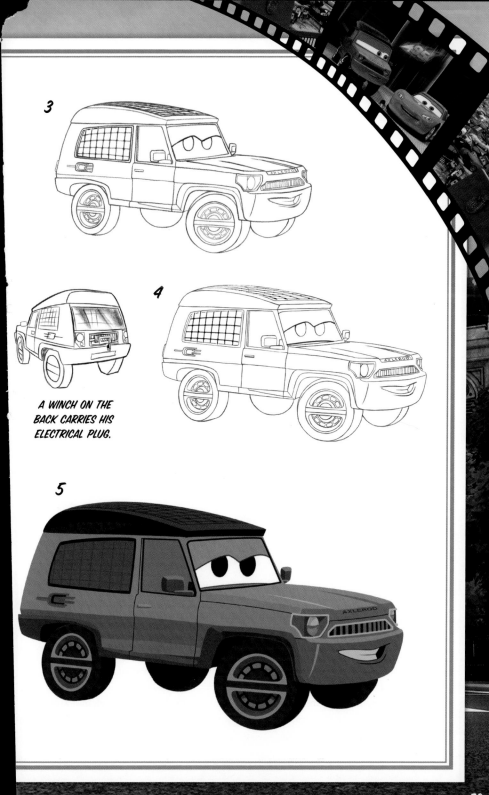

3

4

A WINCH ON THE
BACK CARRIES HIS
ELECTRICAL PLUG.

5

CREDITS